MORRIS LAPIDUS

© 2004 Assouline Publishing
601 West 26th Street, 18th floor
New York, NY 10001, USA
Tel.: 212 989-6810 Fax: 212 647-0005
www.assouline.com

All photographs: © Courtesy of the Morris Lapidus Archives.

Color separation: Gravor (Switzerland)
Printed by Grafiche Milani (Italy)

ISBN: 2 84323 629 0

MORRIS LAPIDUS

DEBORAH DESILETS

ASSOULINE

In 1929, Morris Lapidus arrived in Miami Beach on the last stop of his Caribbean honeymoon. The young architect was immediately taken with this Florida paradise of white sand, blue sky, turquoise waters, and lush palm trees. Eighteen years later, Lapidus would return to Miami Beach and claim the city as his laboratory for architectural design. From 1947 until his retirement in 1983, Lapidus created a dizzying array of bold and innovative designs on Florida's shores—from open-air malls and resort hotels to hospitals, synagogues, and performing arts centers.

By the end of his prolific career, Lapidus would design more than 1,200 projects. Yet until late in his life he remained outside the realm of acceptable architecture. With original and unorthodox talent, Lapidus strove to understand human nature and the emotive language of forms. His architecture emerged as an enigmatic and intimate elaboration of desires that were keenly in step with the American psyche. Despite the continuous wrath of the critics, Lapidus fearlessly based his architectural approach upon concrete human needs—at once functional, yet more importantly, symbolic.

Fortunately, Lapidus lived long enough to see his brilliance fully appreciated; as one critic puts it, his work "epitomizes the American Dream as much as Las Vegas and the Cadillac tailfin." [1]

Development of an architect

Born in Odessa, Russia, in 1902, Lapidus emigrated with his mother and father to America the following year. For two decades the family struggled to make ends meet in New York's Lower East Side, the center of the city's Jewish community. But Morris's father, Leon, was able to rise from metal worker to partner in a manufacturing firm, instilling in his son the reality of the American Dream. Lapidus initially studied to be an actor, but was soon bored by the long stage waits and turned his eye to set design. Told that in order to be a set designer he must first study architecture, Lapidus enrolled in Columbia University's School of Architecture. Immediately fascinated with the prospect of creating buildings and the idea that architecture should have "firmness, fitness, and delight," Lapidus applied himself with great focus. In his final year, with all his design classes finished, he was able to take engineering classes at night and work for prestigious architectural firms during the day. Soon after graduation, Lapidus met Evan Frankel, who was just starting his own retail design business. Morris began to "moonlight" for the firm of Ross-Frankel, intent on making extra money to buy a ring and marry his sweetheart, Beatrice Perlman. With only a few proposals sketched, Morris's designs were garnering commission upon commission, and Frankel asked Morris to join the firm. Lapidus was initially reluctant to give up architecture for store design, but after being offered more money than he could ever make as an architect, he relented and began his career as a retail

designer. From 1929 to 1943, Lapidus designed 450 retail stores across America with Ross-Frankel.

Lapidus had been trained in the Beaux Arts tradition, and was taught to reject modern architecture because "it was ugly." Left to his own devices, though, Lapidus felt free to explore designs that would enhance merchandising, a relatively new field and a truly "modern" problem. "How does someone sell a product?" Lapidus asked and used his store interiors as a "merchandising laboratory." Keen on developing his own psychology of merchandising, Lapidus became an avid people watcher, observing how the behavior of people could be manipulated by design. Lapidus argued that people, like moths, are attracted to light. He called this theory "the moth complex" and believed it to be essential in understanding people's movement through space. "People don't march in a straight line like ants," Lapidus would say, so his designs put the merchandise where people could interact with it—both in and on beautiful cabinets and displays. Instead of the dark, drab interiors traditionally used to sell merchandise, Lapidus created well-lit curvilinear spaces, formed by curving walls and cabinets and reinforced with dropped lighting soffits that were often the shape of the cabinets or floor areas below.

Lapidus's colorful graphics were eye-catching and strategically placed to move people along meandering paths lined with innovative display cases. Ornamental devices, which he dubbed "intentional nonsense," were meant to lure shoppers into his storefronts and through his stores. These devices, called "bean poles, cheese holes, and woggles" by an editor at *Pencilpoint* magazine in the '30s, show up in the work of contemporary designers like Rem Koolhaas, Philippe Starck, and Zaha Hadid.

Lapidus sold by distraction; he played on people's sense of curiosity. For this, he would receive the moniker "architect by choice,

mob psychologist by design" and eventually be called "the father of modern merchandising." Yet Lapidus still had dreams of designing buildings. In 1943, he went to work under his own name, breaking out with a government project (with his father and brothers) to design the signaling searchlight used by the Army and Navy's ship-to-shore landing vessels in World War II. With the family's commission, he created his own office and was soon to embark on the second half of his career—hotel design.

The architecture of Miami Beach

Post-war prosperity produced an optimistic nation desiring all aspects of the "good life." Tourists flocked to sunny South Florida, and Morris Lapidus began to create places where people "dared to live the dreams they dreamed." As associate architect on five hotel projects in Miami Beach—the Sans Souci (1947), the Nautilus (1950), the Algiers (1951), the Biltmore Terrace (1951), and the diLido (1951)— Lapidus began to push the boundaries of the hotel experience. His eclectic mix of forms, colors, and materials created spaces that were opulent and swank; his lobbies, bars, and pools became places to be and be seen. These hotels became his laboratories for hotel design— leading up to the luxury resort hotels for which he is most famous. Within three consecutive years, The Fontainebleau (1954), the Eden Roc (1955), and the Bal Harbour Sheraton (1956) would single-handedly redefine the word "vacation." The resort hotel was born—a one-stop shop catering to any and all vacationers' needs, with hair salons, clothing stores, restaurants, bars, and novelty display areas. Suddenly, guests had little need to venture outside.

The commission for the Fontainebleau came from Ben Novak, one of the original partners of the Sans Souci. The famous curve of the

Fontainebleau breaks from the modern grid to embrace the needs of the weary traveler. "I always hated long corridors where the line of sight was so exhausting," Lapidus explained. "So I curved the corridor, making an apparently never-ending walkway."

While the exterior of the building was extremely modern, Novak had insisted that the interiors be French provincial, albeit Lapidus would argue, a "modern" French provincial. Lapidus went shopping in New York City with a $100,000 budget to outfit the interiors with sculptured marbleheads, terra cotta figurines, and even period furniture. Gold-painted, wooden flying angels were made into lighting fixtures and were placed in the lobby and at each elevator. The Lady Normandy statue (from the Normandy ocean liner) was rescued at this time from the bronze heap for $1,200 and is today estimated to be valued at $1.2 million. This "rubbish," as Novak called it, made the interiors more outlandish than any palace. In fact, Lapidus out-palaced the palaces. In the lobby, huge, oval-shaped crystal chandeliers glittered in the Florida sun. A sub-lobby was so over the top that a velvet rope was put around it, signifying: for viewing only.

Indeed, the Fontainebleau strove to be the most opulent hotel in the world at the time—and the critics couldn't say enough bad things about it. But while he was being called "the schlock-meister," his excessiveness struck the mood of a country that longed for a place to parade and show off the good life. People would make a movie star entrance floating down the "stair to nowhere" and landing in the glittery lobby. Lapidus gave every Jane and Joe America a taste of the "celebrity lifestyle"—once in the Fontainebleau, you knew you had arrived. Even Hollywood came to film 007's *Goldfinger* (1964) as well as *The Bellboy* (1960). Years later, Lapidus summed all this up with the retort, "Why be exotic in private?" In 1954, Lapidus began to design for Harry Mufson, Novak's partner at the

9

Sans Souci, the Eden Roc, which was situated right next door. Vowing to steer clear of the curves that critics had found so offensive, he selected a straight-lined Italianate style.

Lapidus designed the building in the form of a Y, with the two arms embracing a swooping curved driveway as the leg of the Y extended toward the ocean. The driveway was covered with a candy-striped canopy held with thin carousel-like columns. At the entrance, Lapidus placed a gondola-shaped fountain and floated in it a replica of the *Winged Victory of Samothrace*. The geometric sternness of the façade was broken with color: rose-hued frames held double-height curtain walls of glass, and stair towers clad in vibrant mosaic tiles ascended to the sky. At the rear of the building and on the side wings, dramatic tray-like balconies layered up the fourteen floors like Italian opera boxes. Albeit half the size of the Fontainebleau, the Eden Roc commanded an equally dramatic presence on the shores of Miami Beach.

Inside, a circular sunken lobby with a dropped oval ceiling floated in a room of floor-to-ceiling glass walls covered with draping Venetian curtains, and over-scaled anthemion patterns in dark green and cream marble on the floor captured perfectly the wit and feeling of Italian elegance. But it was still too much. The critics claimed that "Lapidus had gone mad."

But by now Lapidus had stopped caring about the critics. He had come to terms with the fact that the impersonal minimalism of the International Style left him cold. He wished to debunk the Bauhaus totemic "less is more" with "too much is never enough."

Lapidus would show no restraint in the Bal Harbour Americana. The developer, Loew's Theatres, wanted "a Lapidus design" and they got what they paid for. For the lobby, Lapidus designed an 80-foot opening in the ceiling surrounded with angled glass curtain walls, which allowed natural light to flood the interiors. On the

circular-cyclorama walls, full-height mosaics displayed the conquerors of the Americas. Lapidus's Aztec-like open-mesh bronze screen encircled the lobby with reflected, shimmering light. Clearly ahead of Disney in his ideas of "edu-tainment," Lapidus's spaces were informative and fun.

Lapidus went on to design hotels on remote islands in the Caribbean and other exotic destinations. Somehow, Lapidus always managed to arrive first upon the scene, defining the resort hotel experience in Aruba, Jamaica, Puerto Rico, St. Thomas, Paradise Island, and the Florida Keys. The last hotel of his career, and the most opulent, would be the Daniel Tower Hotel in Israel. Within ten years, Lapidus—with a staff of more than forty in New York City and twenty in Miami Beach—came out from behind the shadows of his retail career and emerged as a world-class architect. All told, Lapidus designed more than 250 hotels around the world.

Living spaces

But the Lapidus oeuvre was hardly limited to hotels. The Lapidus Office Project List registered more than 142 apartment housing projects in South Florida. A few of his most noted houses along Collins Avenue included the Crystal House (1960), Seacoast South (1963), Seacoast East (1965), Bal Harbour 101 (1961), the Tropicana (1969), and Arlen House West (1969). By the end of his career, Lapidus had designed hundreds of thousands of apartments or "living spaces" in not just Florida, but also in the urban areas of New York, Virginia, and Washington. Lapidus left his signature in luxury wherever he went, but he would hit his stride in a city yet to exist: Adventura, Florida.

Adventura was the fantasy of Don Soffer, who hired Lapidus to turn the dredged mangrove swamp, called the "Milk Man Tract," into a dream city of luxury living spaces. Lapidus was the head architect of Adventura for more than a decade, building twenty-nine luxury condominiums and apartments that ranged from six-story to twenty-nine-story, complete with swimming pools, cabanas, and clubhouses—in short, all the requisites for sophisticated Florida living. Perhaps Lapidus's most photographed interior living space was in his own home. In 1957 he began the design for the first high-rise apartment building on Miami Beach, the Terrace Towers Apartments at Belle Isle. Completed in 1961, he would live there until his death. The design of his home interiors was as lavish, ornate, and detailed as any of his retail interiors. Here was a home that could aptly be called a *petit palace*. Each surface either reflected an opulent soft wash of colors or screamed fuchsia and pink (his favorite). Downstairs, a Spanish bar was reminiscent of a design he had created in the '20s for a school project. For more than thirty-three years—save the addition of more exotic objects, collected from their travels all over the world—the couple's apartment remained unchanged. The couple's objets d'art came to be known as the Lapidus Collection; at his death, they were bequeathed to the Bass Museum, per his wishes.

Floating cities

In 1943 Aetna Marine asked Lapidus to convert a Liberty Ship into a cruise liner. Thirty years later, these sketches were shown to Ted Arison, a young man with an ambition in the new cruise industry in Miami. Soon after Arison saw these sketches, Lapidus was hard at work to meet a two-week deadline to prepare the launch of Arison's

first cruise ship, the TSS Mardi Gras. On March 11, 1972, the ship sailed, and Lapidus sailed along with it. With the success of the Mardi Gras, Arison bought a second ship, and Lapidus was again called upon to outfit it. Lapidus redesigned the corridors and the public rooms, and even designed the interior art—decorative objects silk-screened unto the back of Lucite panels. With this second ship, the TSS Carnivala, the Carnival Cruise Line was launched.

Lincoln Road

In the '50s and early '60s, Lincoln Road was the Fifth Avenue of Miami Beach, lined with some of the country's finest stores. But with the rapid influx of luxury resort hotels, which were virtually self-contained cities, hotel guests no longer ventured outside the grounds for amusements. Merchants along Lincoln Road were losing revenues, so in 1959 they went to see Lapidus for help in solving the problem.

For the next two years, Lapidus designed Lincoln Road as a walking mall occupied by fun and fantastical shapes. Concrete whimsical structures, called "follies," identified each block, and black and white piano stripes marched up and down the sidewalks. Arguing that "a car never bought anything," Lapidus asked city officials to block off all streets and create bridges for the cars, but they wouldn't go for it. Nevertheless, for the next fifteen years Lincoln Road was the heart of Miami Beach—the place to see and be seen. Economic forces caused a decline of the mall in the late '80s, but after its reconstruction, with Lapidus's help, in the mid-'90s, Lincoln Road has again become the hub of Miami Beach.

Lapidus's legacy

While his architecture was dismissed as vulgar in the '50s, by the end of his career Lapidus was asked to work with a number of prominent Miami architects to preserve and enhance his work.

John Nichols, president of The Nichols Partnership, worked closely with Lapidus when he was hired at the turn of the century to renovate two of Lapidus's icons. Nichols turned the diLido Hotel into the Miami Beach Ritz Carlton, and created the new Fontainebleau III Tower adjacent to the Fontainebleau. "Lapidus was an intuitive architect. His work was purposeful—not frivolous; it could be playful, but very thoughtful." Nichols pays homage to Lapidus's love for the curve in the new serpentine connector corridor that connects the three buildings that now comprise the Fontainebleau.

On December 15, 2000, the Cooper-Hewitt Museum in New York City presented Lapidus with the American Original Award, the first of its kind given by the museum. As he stood in front of family and friends, Lapidus delivered a gracious acceptance speech. After so many years, Lapidus had finally arrived.

Lapidus lived to the venerable age of 98, and was fond of saying that the times hadn't changed, the critics had died. Lapidus's bold notion of "giving the people what they want" continues to ignite controversy and is one of the core questions concerning "good taste" that is still debated today. Lapidus dared to go against the establishment, using light, ornament, and color to create his emotive and flowing architectural style. At a time when American architecture suffered form being cold and austere, Lapidus brought back the human element. In later years, Lapidus's style was called Miami Baroque. Charles French would use a photograph of Lapidus's zepplin shaped column in the Eden Roc as his first sighting of what he coined the "postmodern" style. Robert Venturi

and Denise Scott Brown would also credit Lapidus in their writings. More recently, his work is seen as the start of Miami Tropicalism.

Lapidus's life spanned a century of change yet he was a living bridge between the old and the new. Lapidus studied people, not geometry, and his architecture is as varied as the needs of people.

In 1957, Riverside Chapel on Miami Beach was designed by Morris Lapidus. In January 2001, forty-four years later Morris' final eulogy would be delivered in those same halls by his son Richard, with family and friends in attendance. Lapidus and his "architecture of joy" was remembered in obituaries around the world as far away as London, New Zealand, and Singapore. He battled the good fight for ornament and for emotion and motion in architecture. Three years earlier, Lapidus had given these encouraging words to a gathering of Columbia architectural students: "Use your head, your heart, and your hands—feelings find form."

1. Sanders, Joel, "Contaminated Modernism," *Bauwelt Magazine*, 1995.

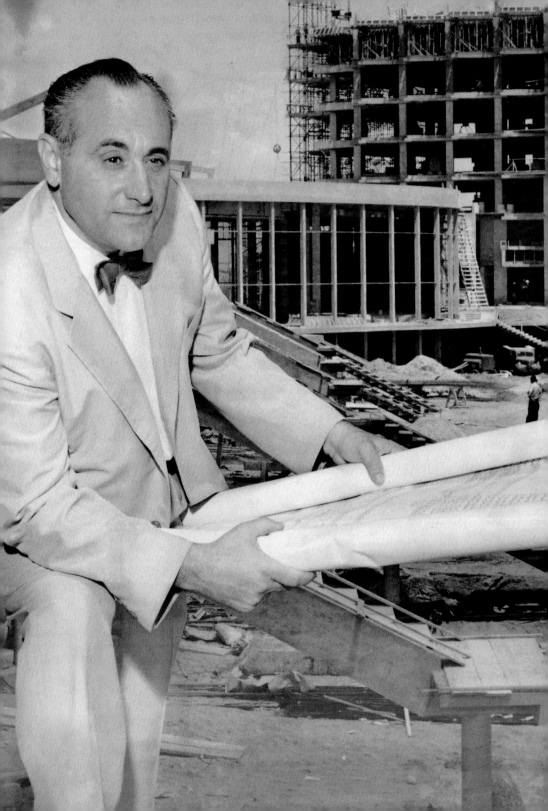

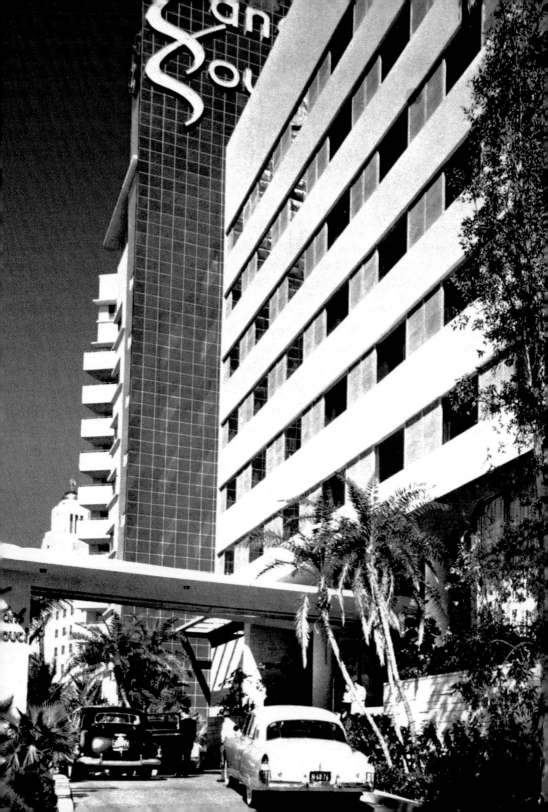

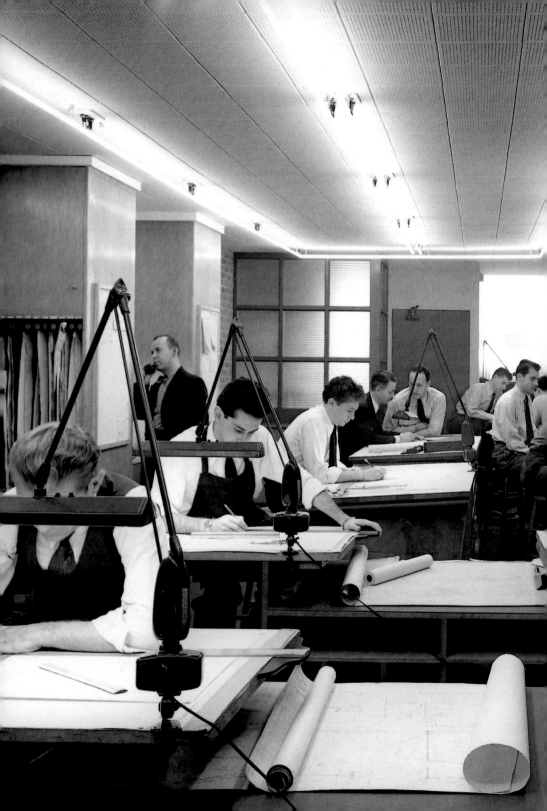

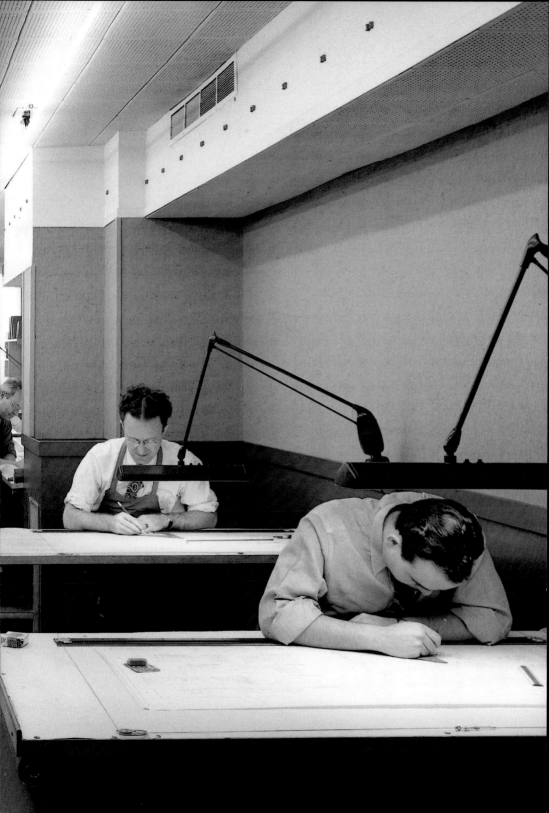

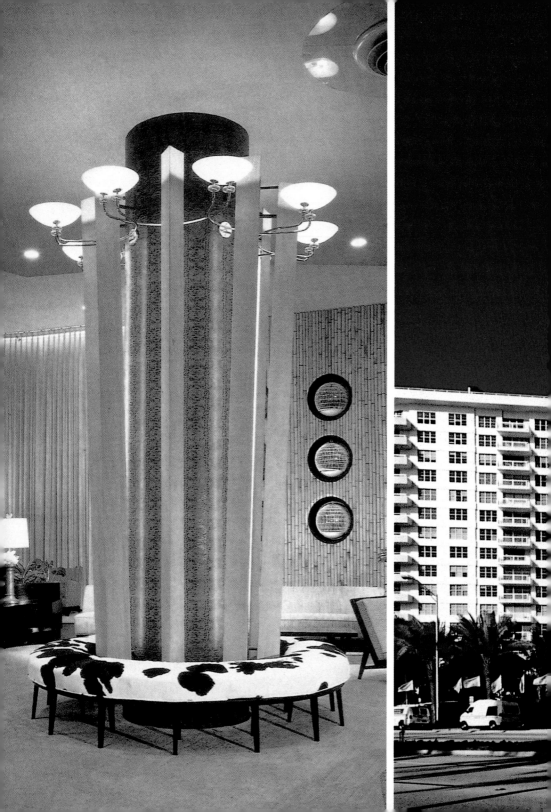

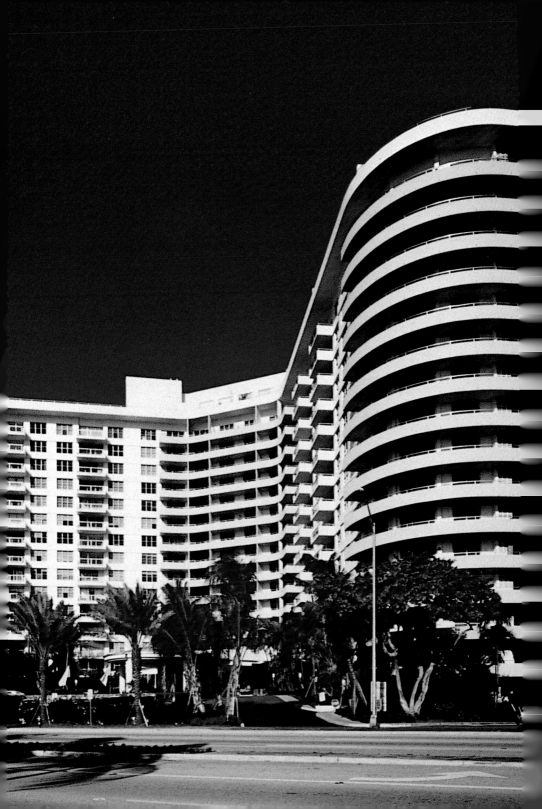

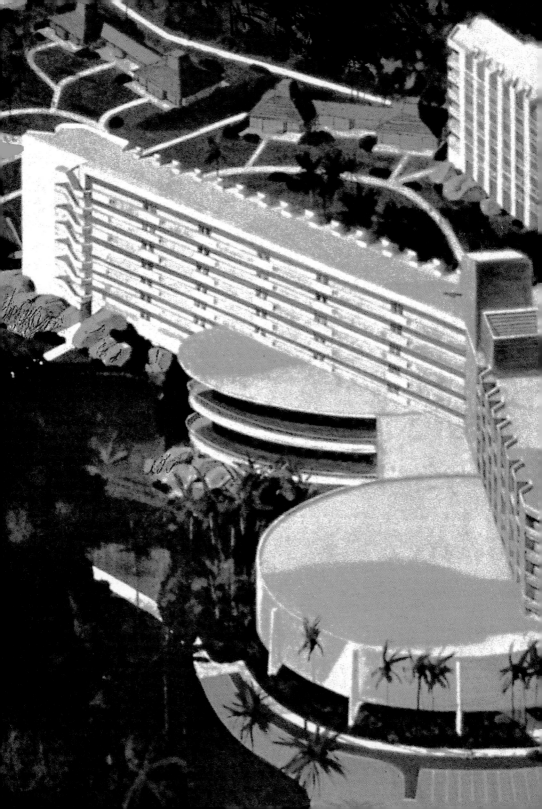

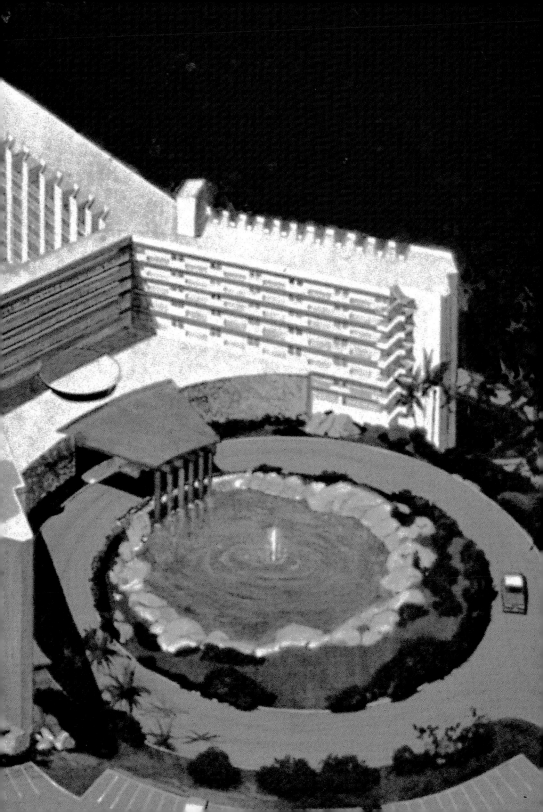

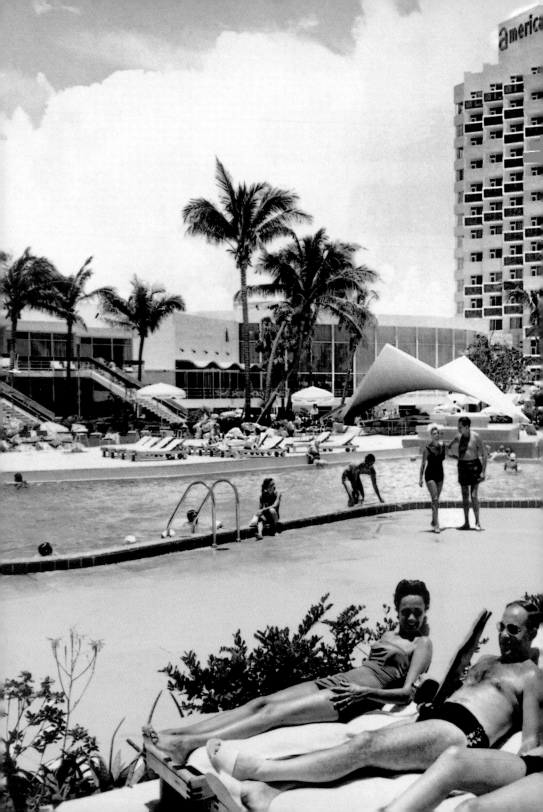

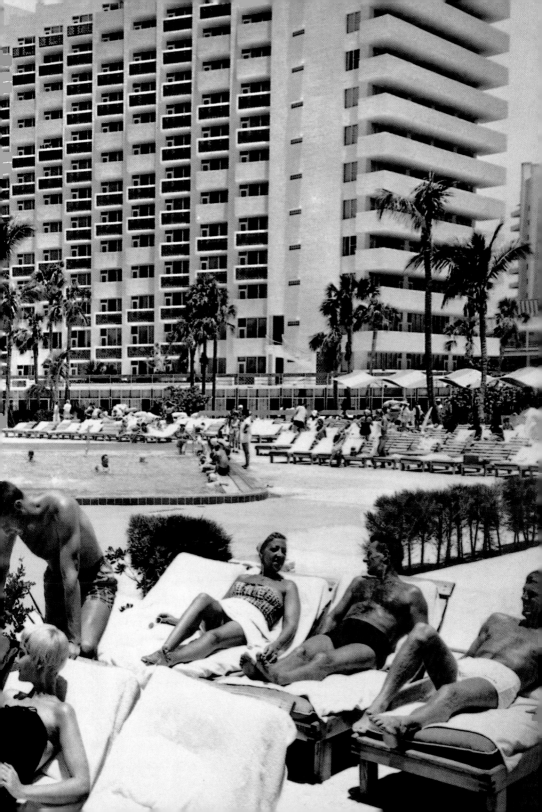

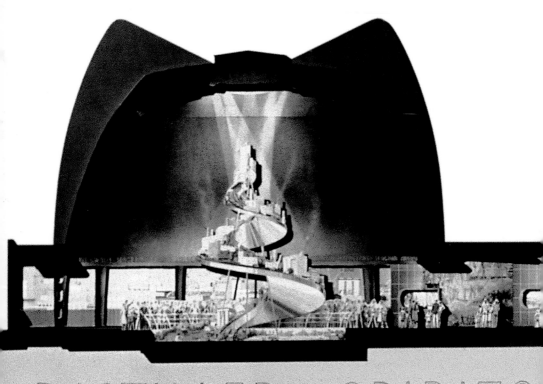

· DISTILLED · SPIRITS
· NEW · YORK · WO

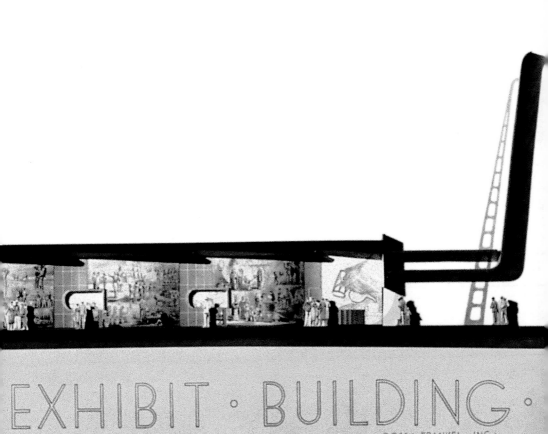

EXHIBIT · BUILDING ·

D'S · FAIR · 1939 ·

ROSS ~ FRANKEL · INC ·
· MORRIS · LAPIDUS · ASSOC ·
· NEW · YORK · CITY · N·Y·

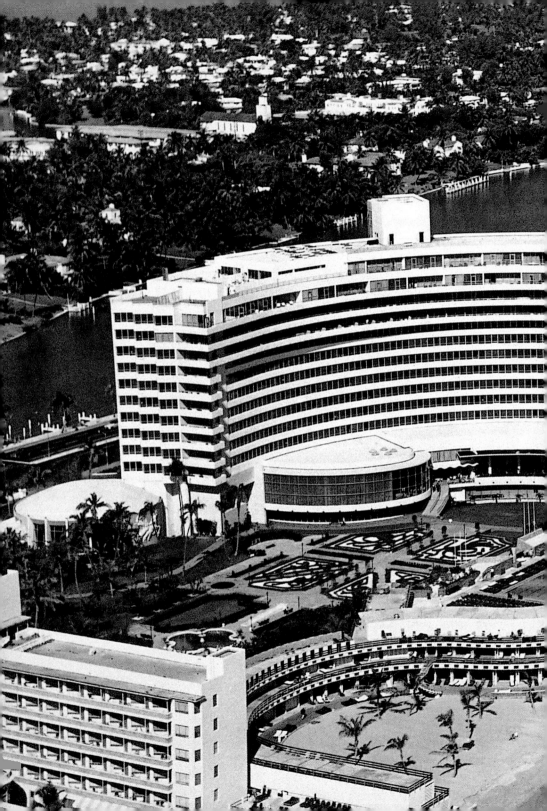

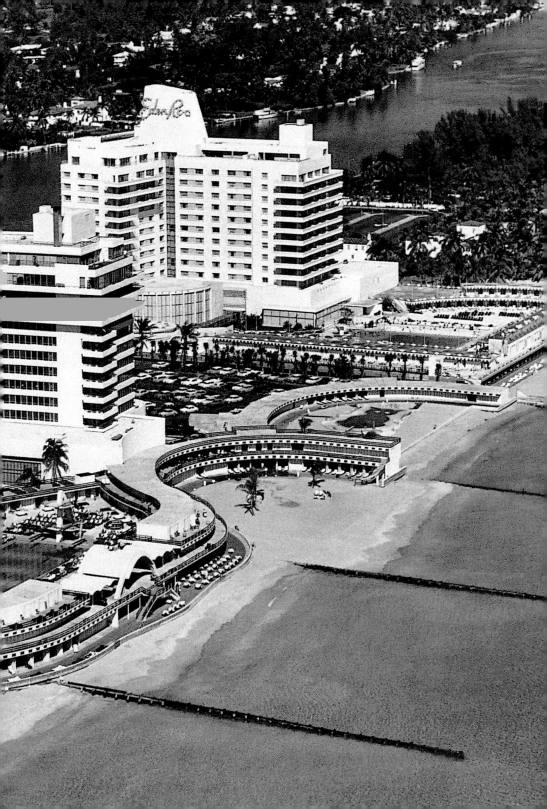

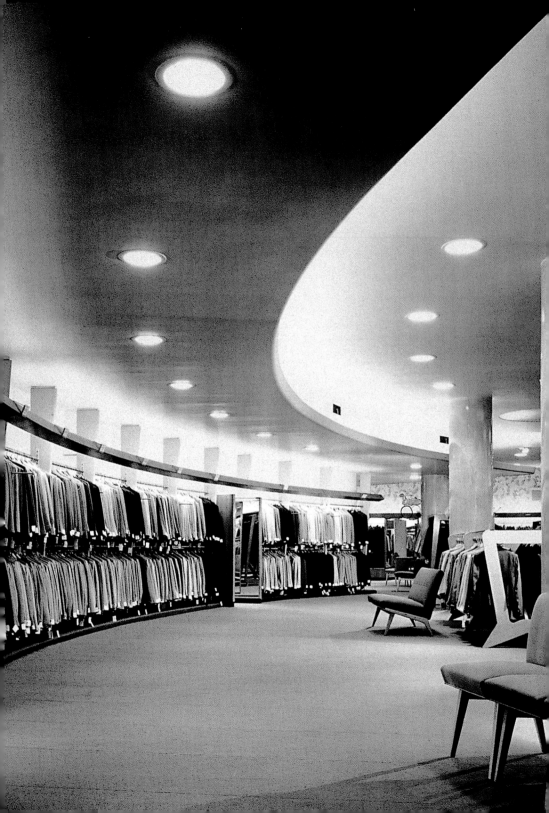

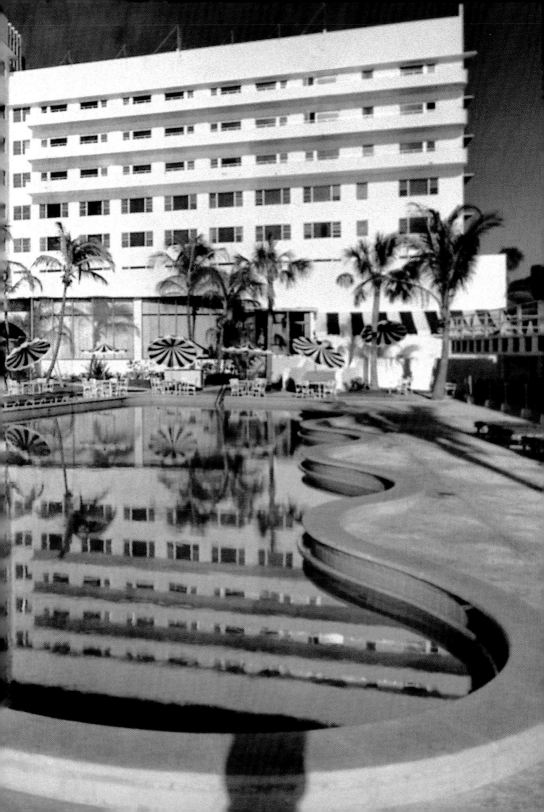

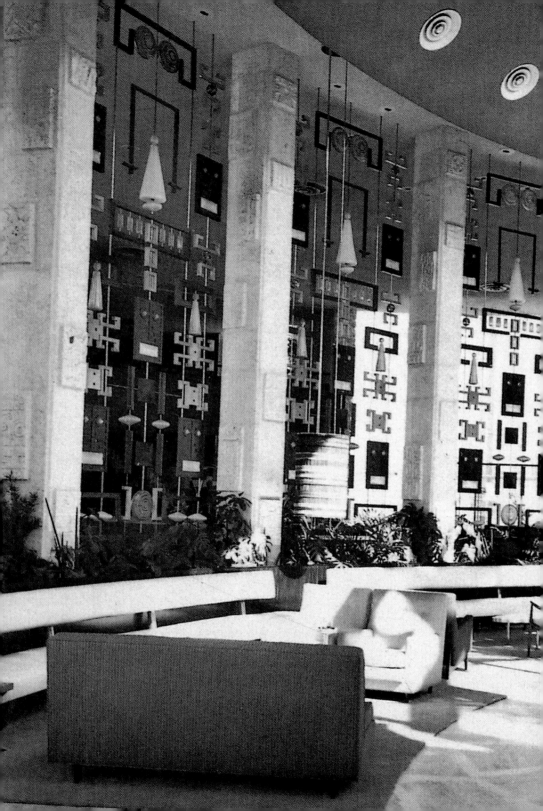

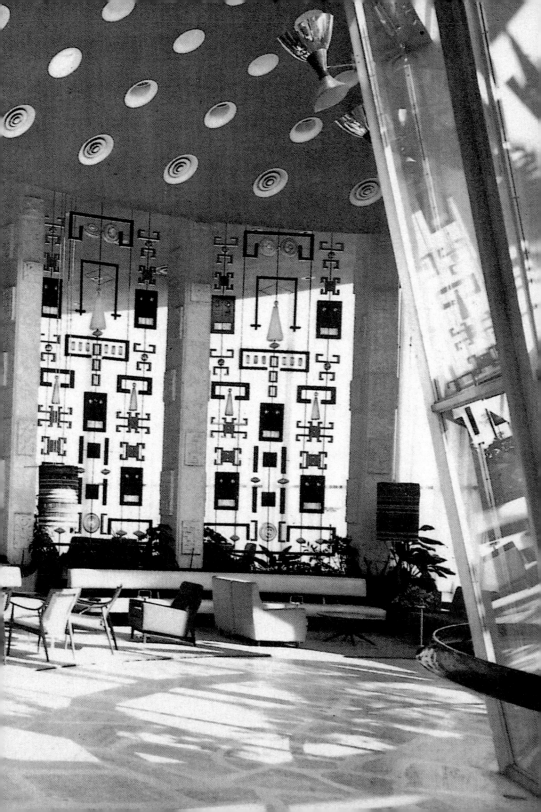

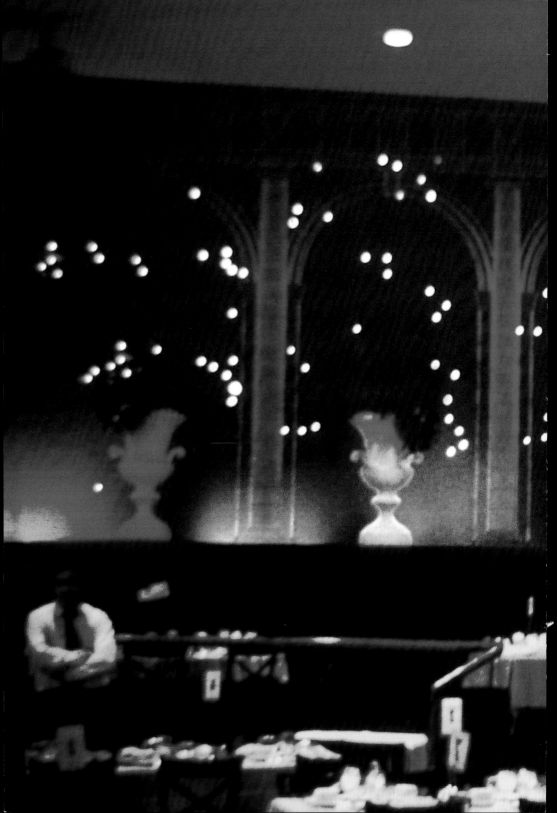

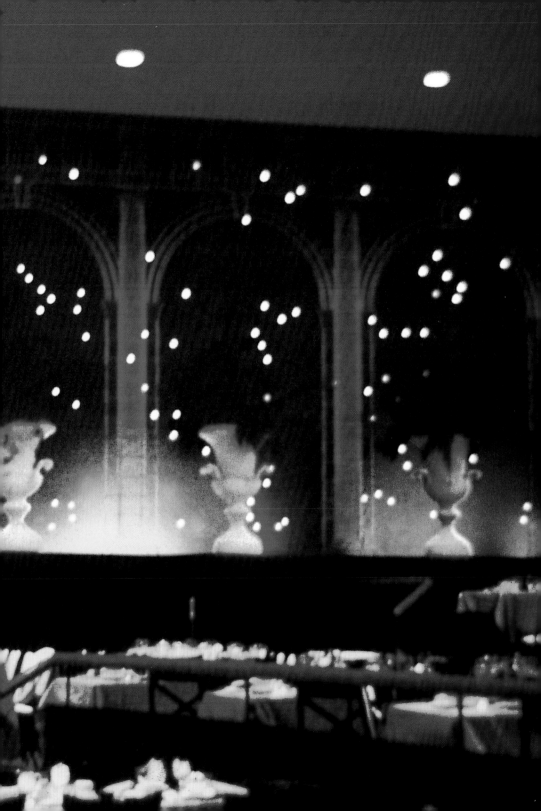

FORSYTHE
shoes

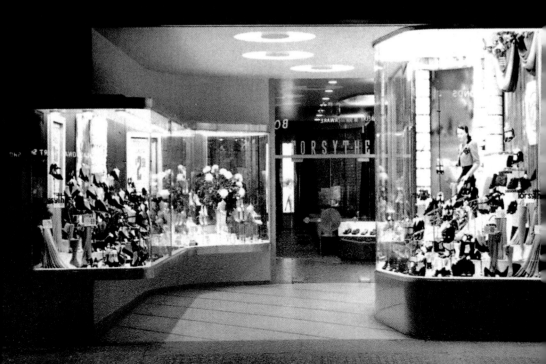

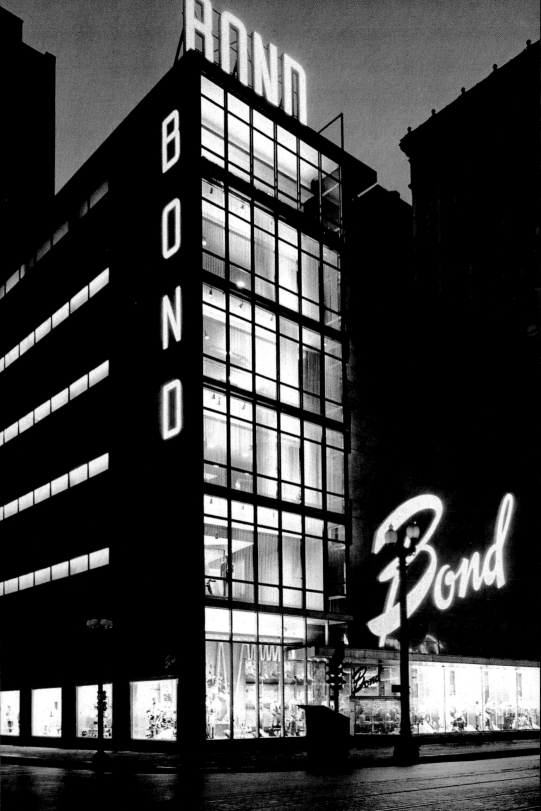

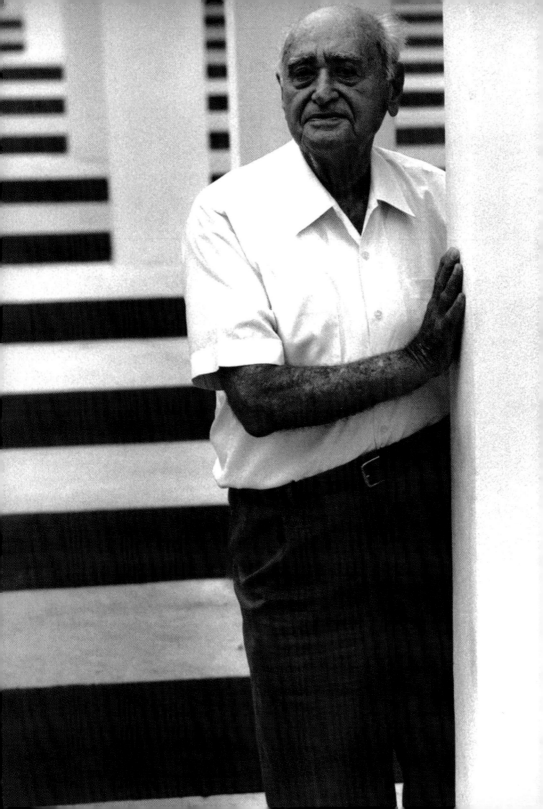

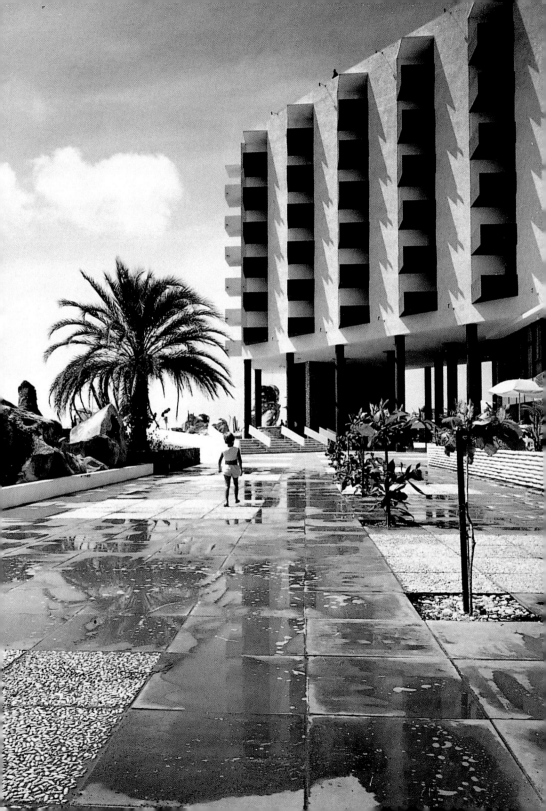

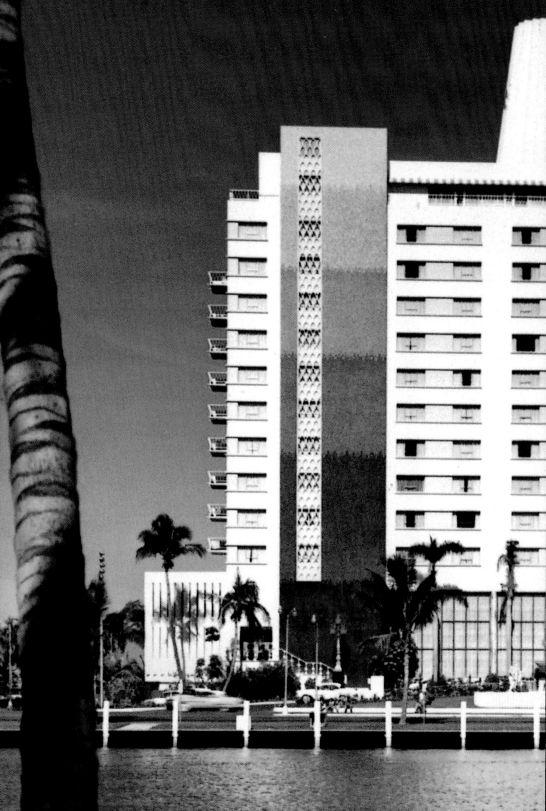

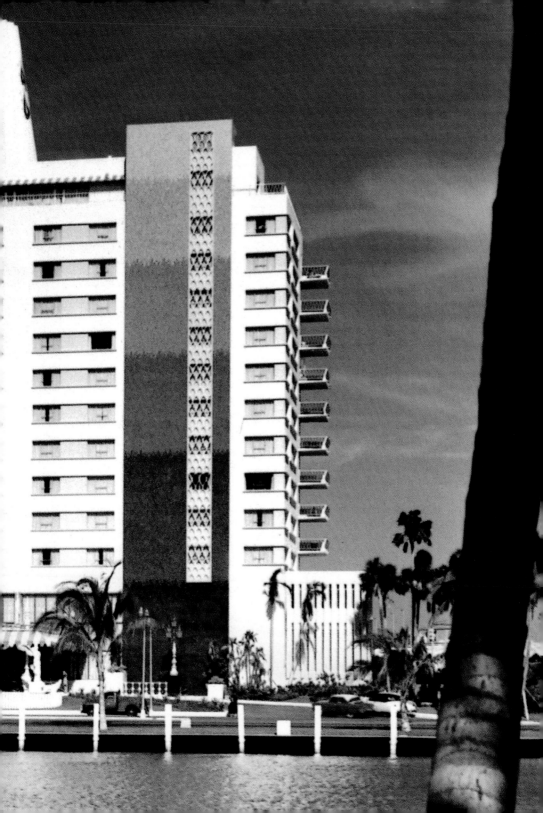

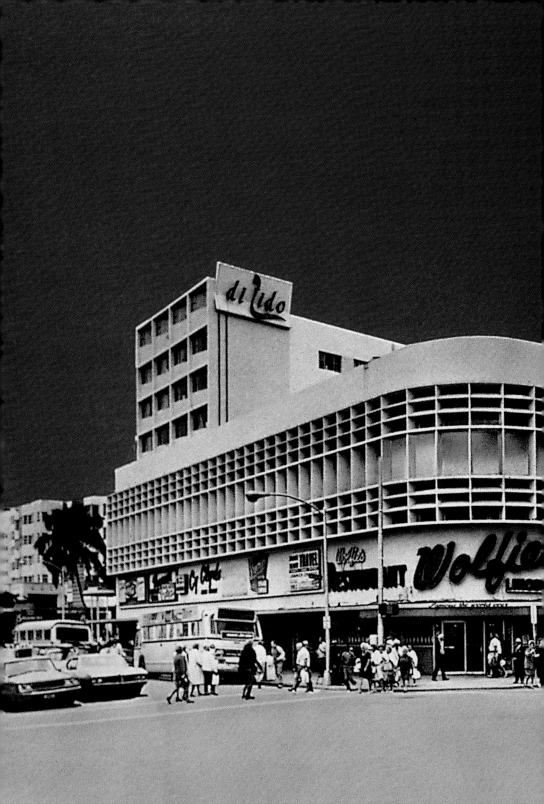

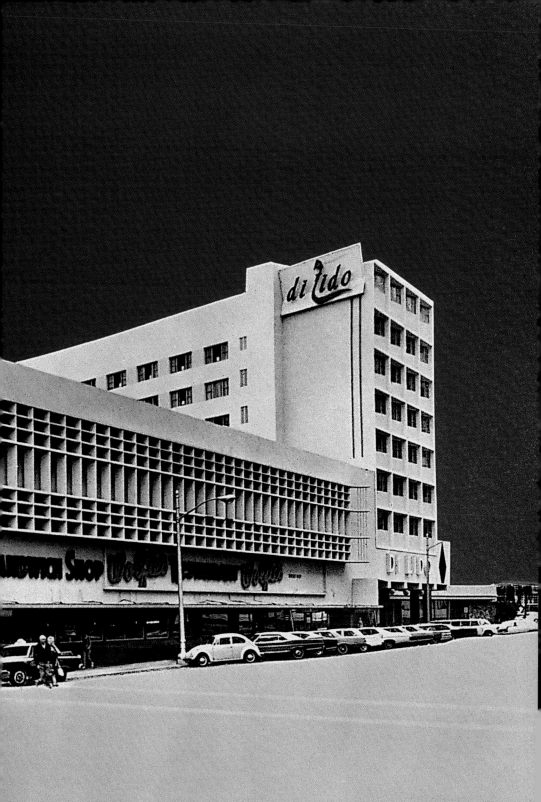

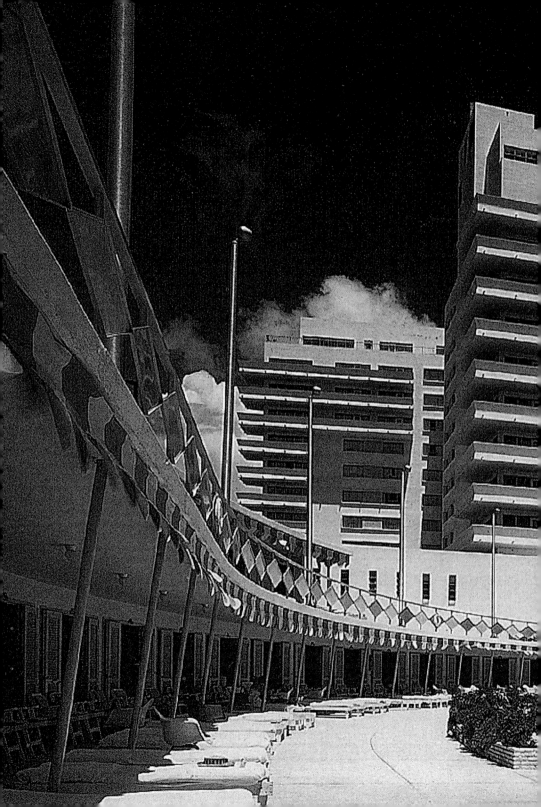

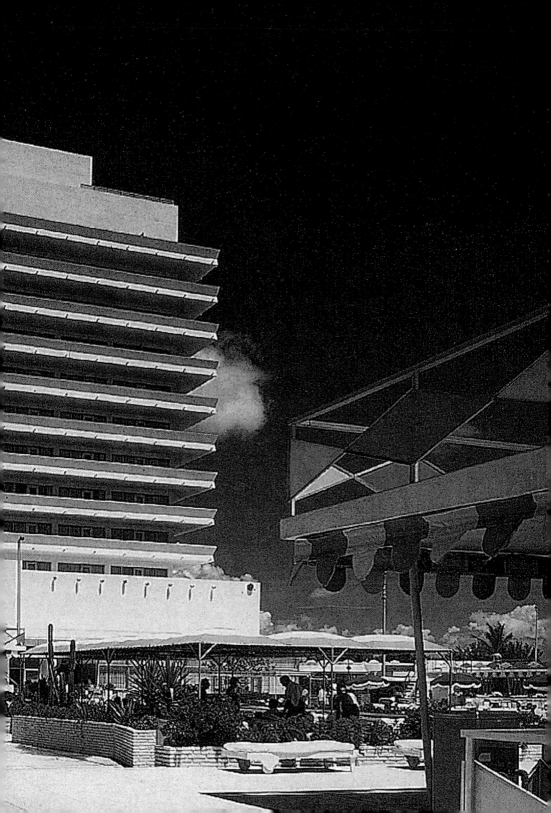

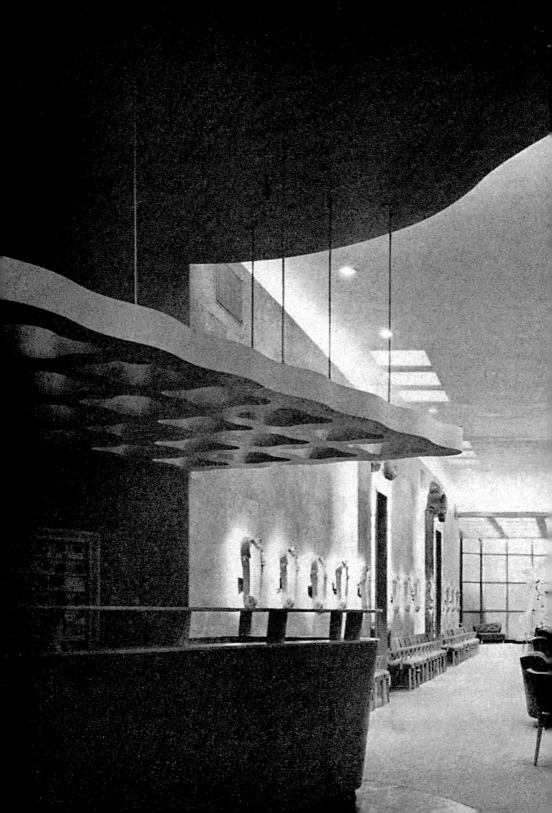

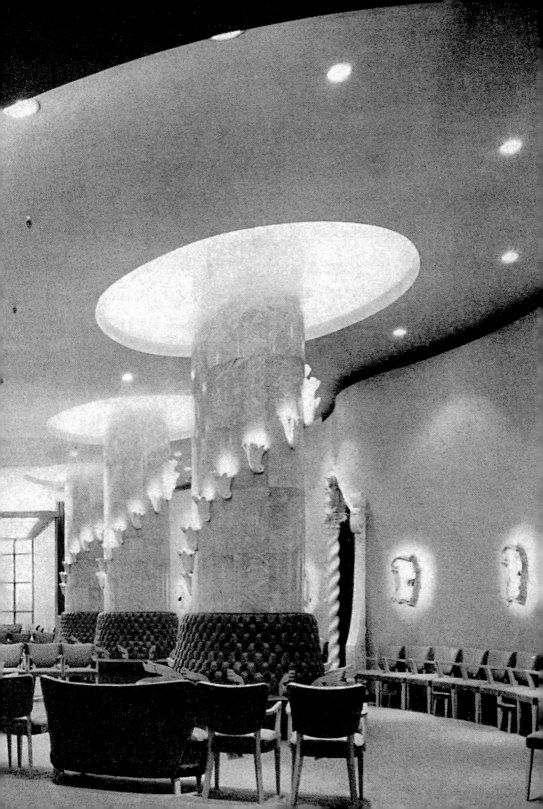

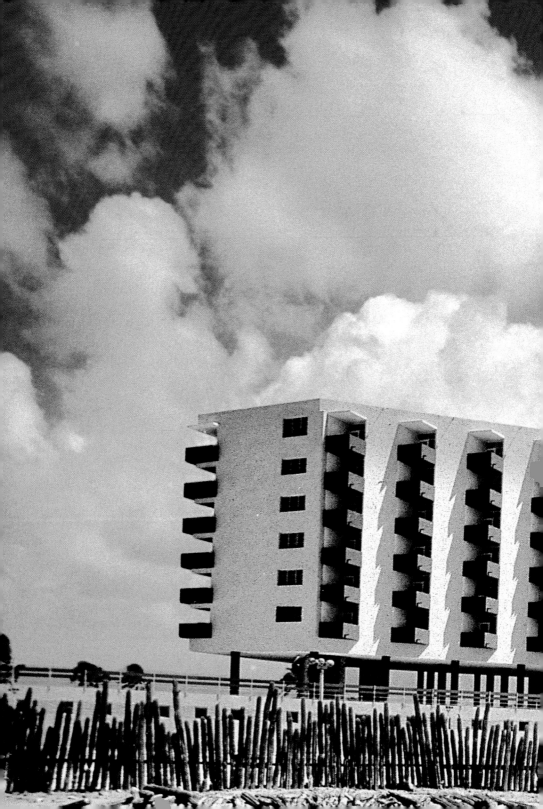

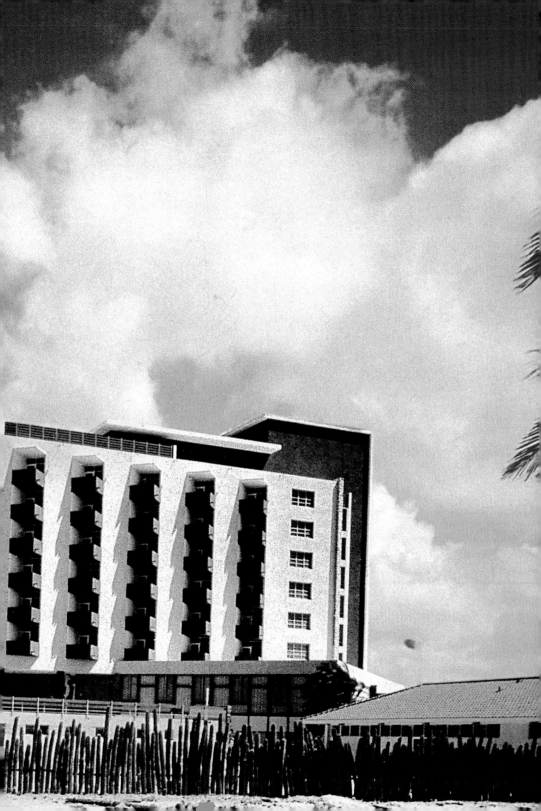

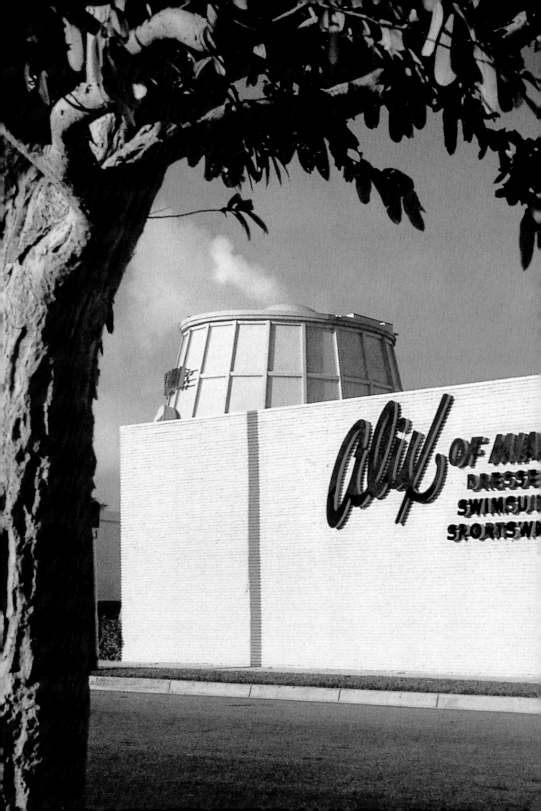

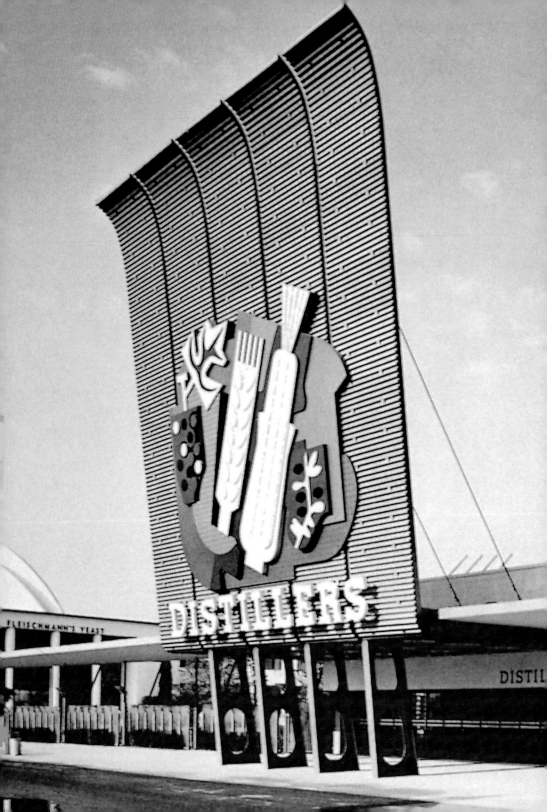

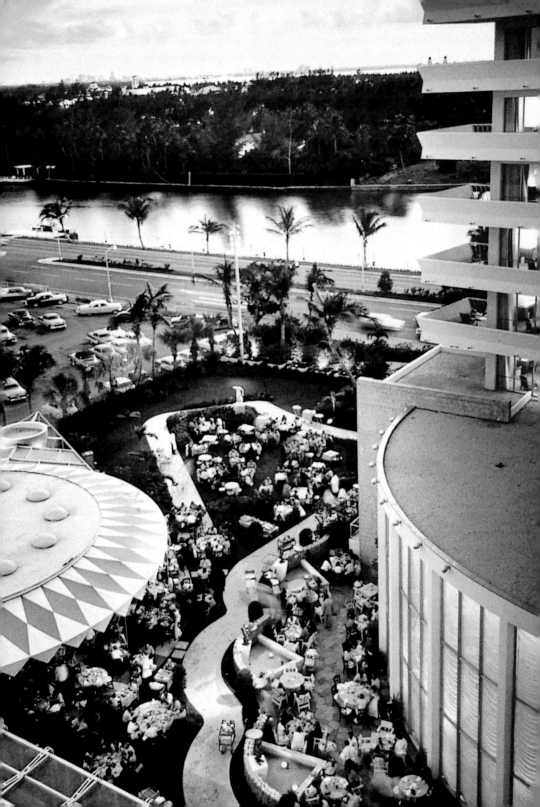

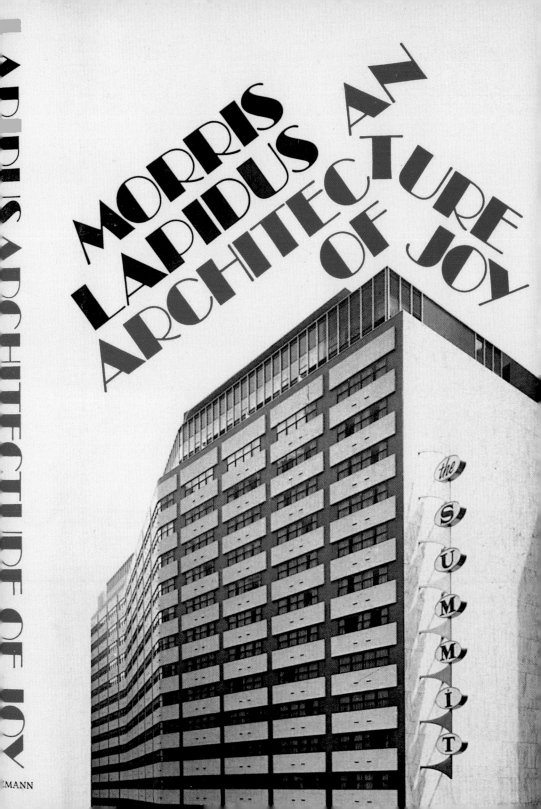

MORRIS
LAPIDUS

ARCHITECTURE
OF JOY

the SUMMIT

ISABRIS ARCHITECTURE OF JOY

EMANN

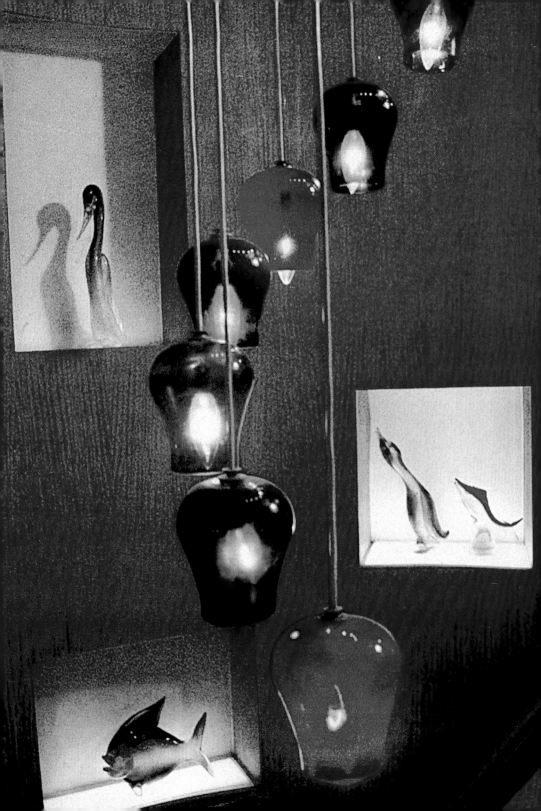

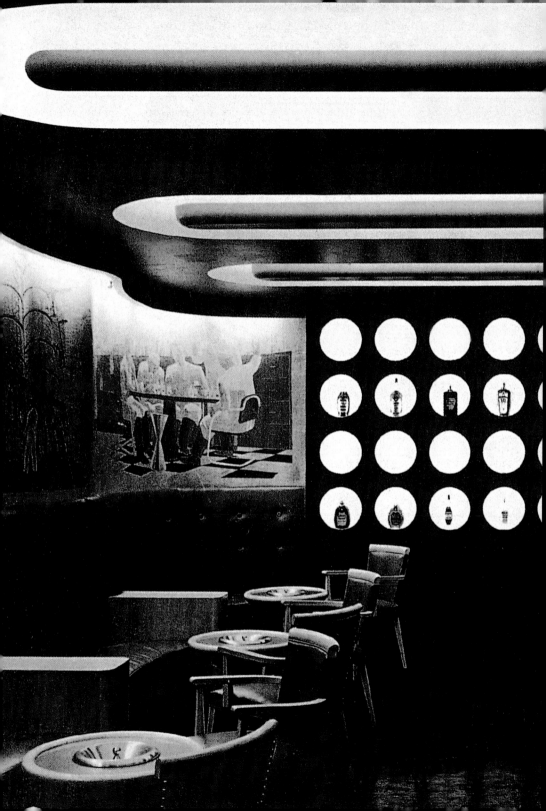

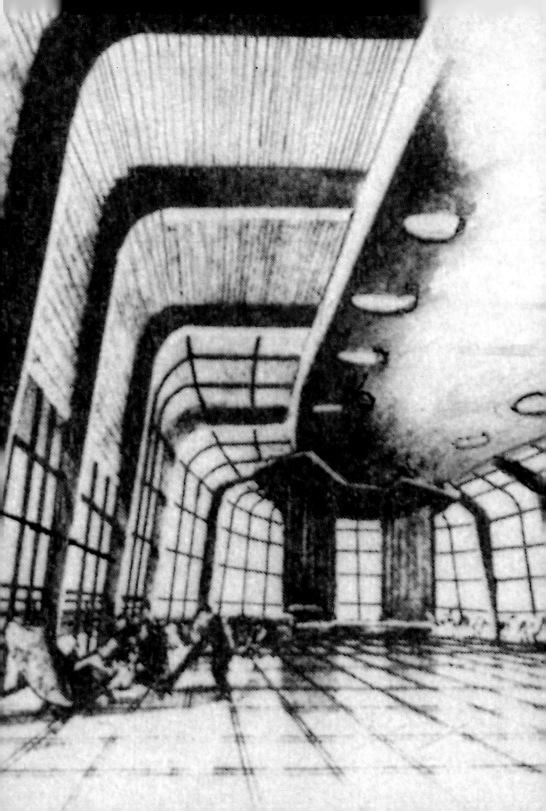

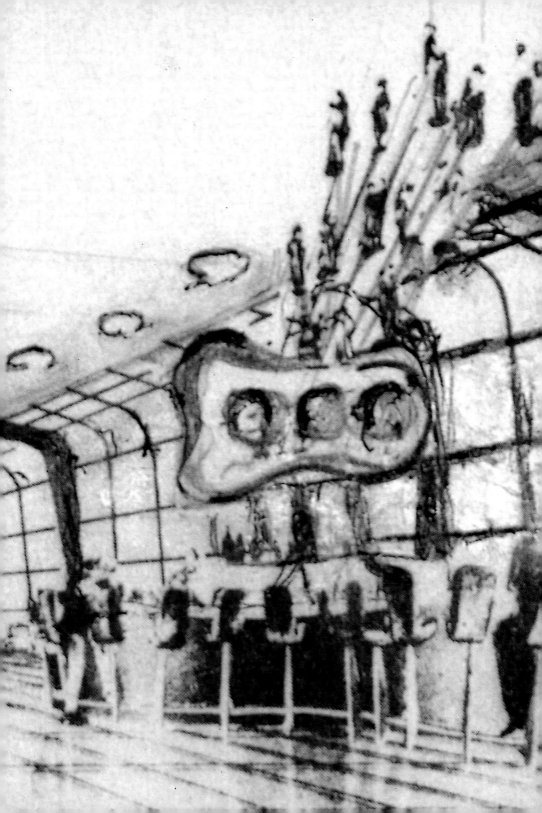

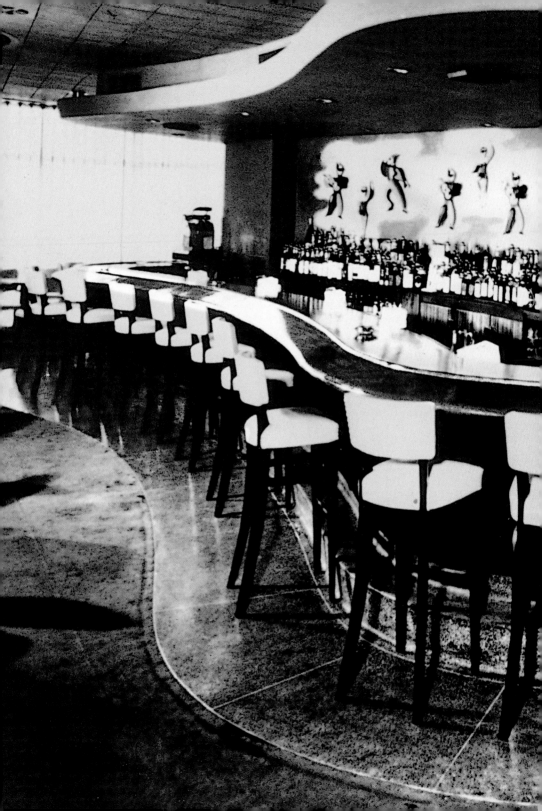

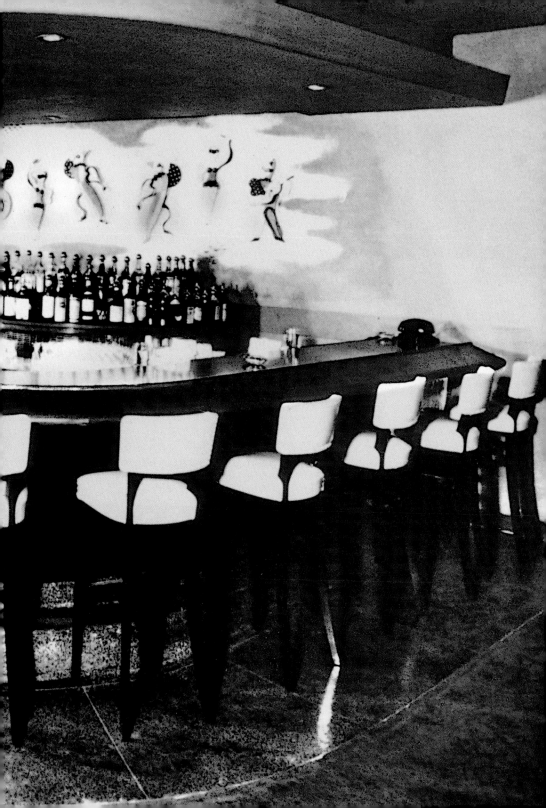

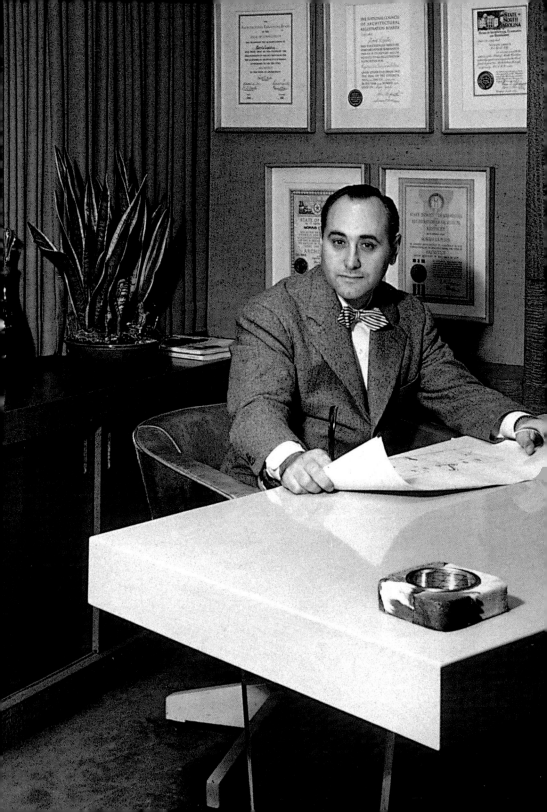

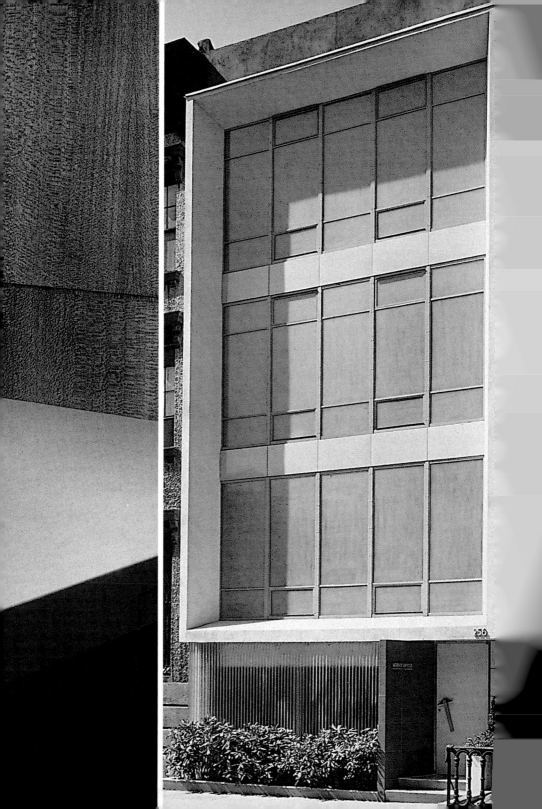

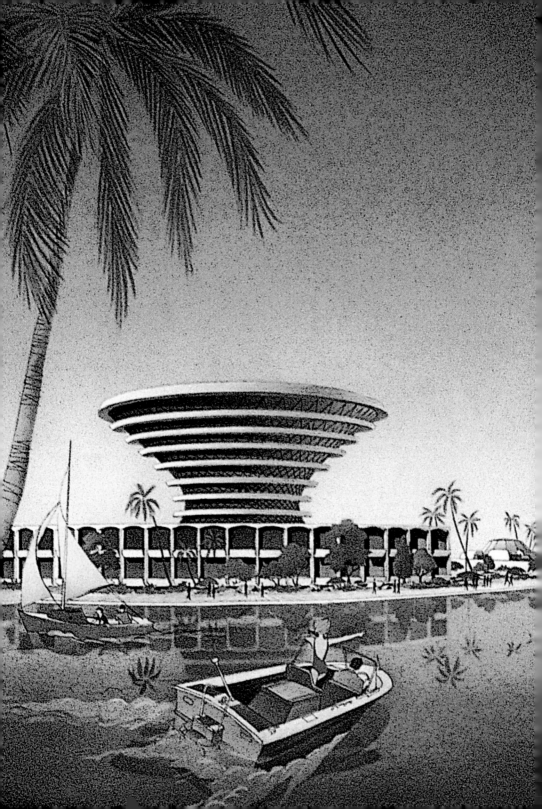

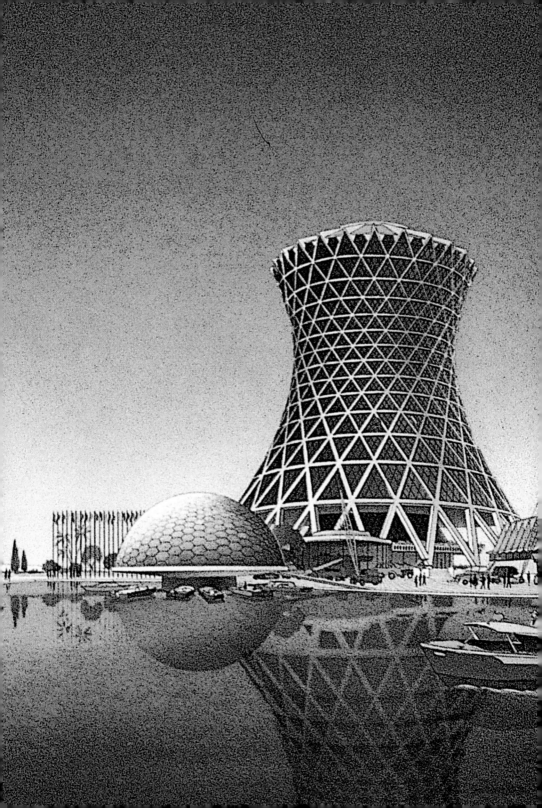

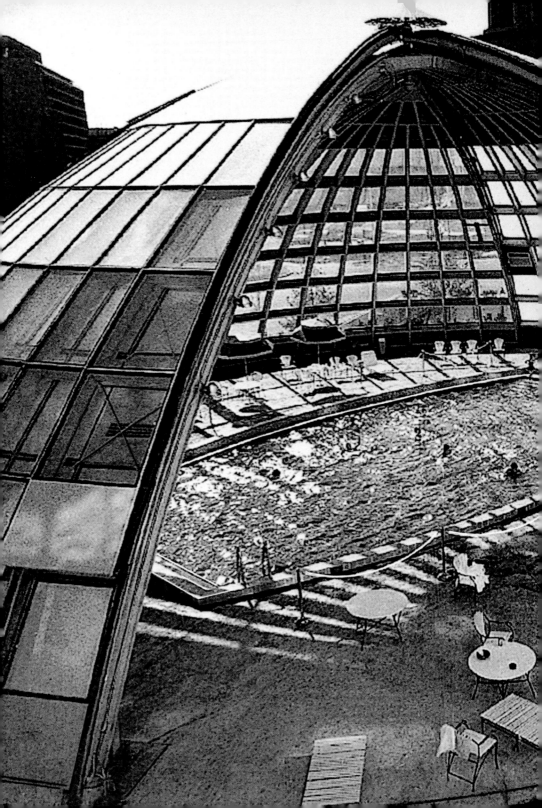

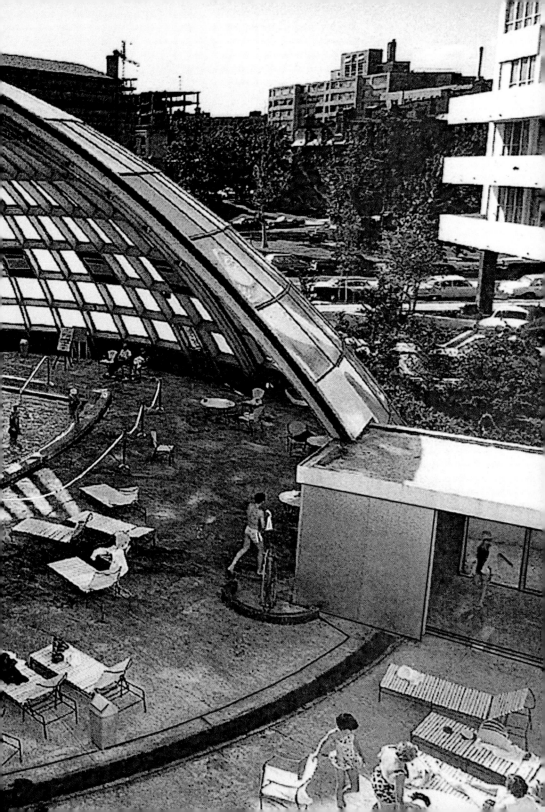

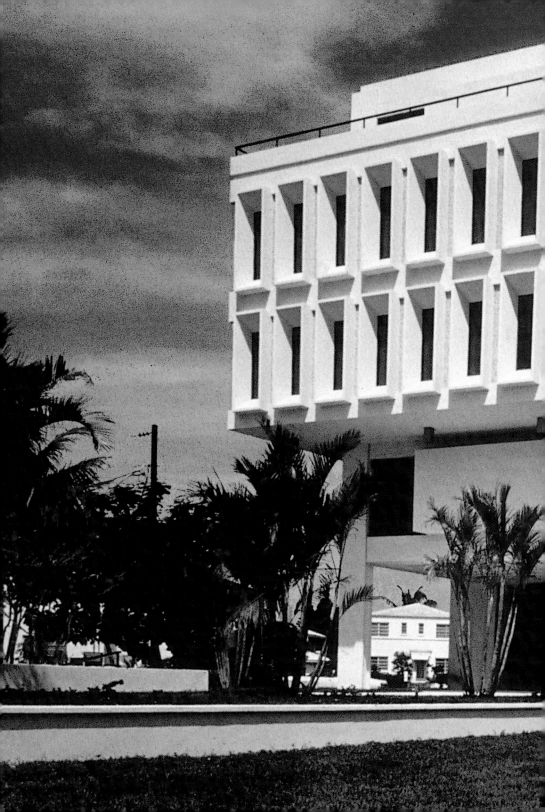

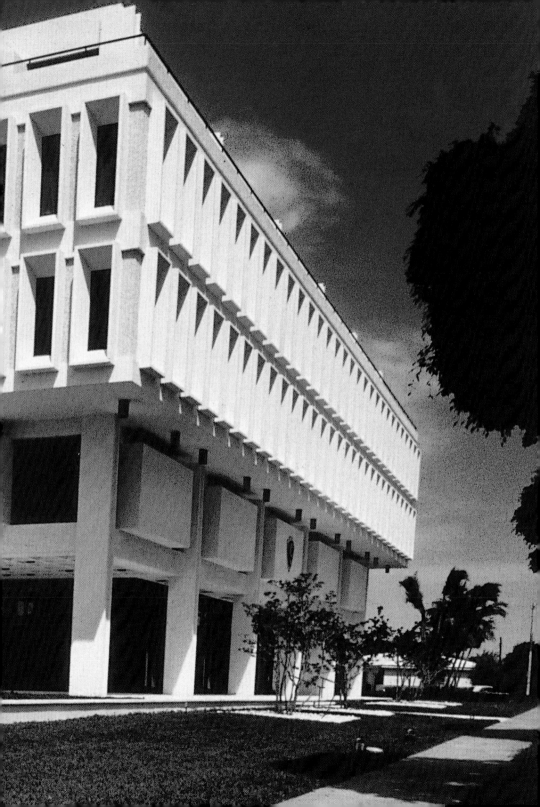

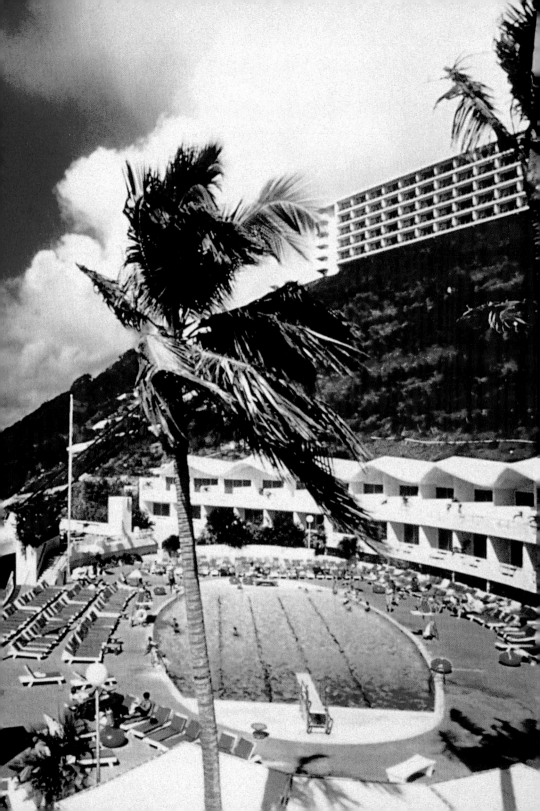

Chronology

1902: Morris Lapidus is born on November 25, in Odessa. Deciding her son will not endure the horrors of Russia, Lapidus's mother convinces her husband that the small family should flee to America.

1903: Lapidus and his family arrive at New York's Ellis Island.
The family moves to the Lower East Side of Manhattan.

1922: Lapidus enrolls in the drama department of Washington Square College of New York University.
He soon joins the Washington Square College Players, where he is made the scenic artist and costume designer.

1925: Lapidus quits acting and enrolls in Columbia University's School of Architecture with the intention of becoming a set designer.
Lapidus meets Beatrice Perlman, whom he will eventually marry.

1927: In his last year of study, Lapidus attends courses at night while working during the day.
Lapidus designs the ornament for the Vanderbilt mansion; his designs for a marble bathtub cause Vanderbilt to exclaim, "I am not a Rockefeller, I can't afford that bath."

1928: Lapidus begins work as a chief draftsman for an architectural firm, and in his spare time, he designs storefronts for Ross-Frankel.
Lapidus decides to go full-time into retail design.

1929: On February 22, 1929, Lapidus marries Beatrice Perlman. The couple embark on a honeymoon cruise to the islands before finally landing in Miami Beach, where they explore the island for five days.

1931: Lapidus's design for The Parisian Bootery on New York's Fifth Avenue is published in *Architectural Forum*.

1934: Lapidus designs stores all over the country, traveling to Chicago, San Francisco, Galveston, and New Orleans.

1937-1939: Lapidus works in association with Morris Sanders on the design for the Distillery Building for the 1939 World's Fair.

1943: Lapidus's father's company is commissioned to design the signaling searchlights for the U.S. Army and Navy. Leon Lapidus asks his son to collaborate on the design, and this family-designed project pays Morris enough to set up his own firm, Morris Lapidus Architects.

1947: Lapidus is introduced to developer Ben Novak and begins working as an associate architect for Novak and his partner, Harry Mufson.
Earning the title "hotel doctor," Lapidus "doctors" the design of five hotels in Miami Beach.

El Conquistador, Fajardo, Puerto Rico, 1965.

1952:	Lapidus begins work on the Fontainebleau for Novak.
1954:	Lapidus begins work on the Eden Roc for Mufson, on the site adjacent to the Fontainebleau, fueling a feud between Mufson and Novak. An enraged Novak forbids Lapidus to "step one foot" inside the Fontainebleau.
1956:	Lapidus designs the Bal Harbour Americana for Loew's Theatres and goes on to create five additional hotels for the company in New York.
1957:	Lapidus begins to design Lincoln Road pro bono. He is determined that it will be a pedestrian mall since "a car never bought anything." Four years later, in 1961, his outlandish designs are approved and the mall becomes hugely popular.
1960-1961:	Lapidus returns to New York to design the Summit Hotel, the first new hotel built in New York in thirty years. The design is panned by the critics who say it is "too far from the beach." Lapidus writes *A Quest for Emotion in Architecture*.
1962:	Lapidus is commissioned to design an International Style apartment building, the Crystal House, in Miami Beach. The resulting building has glass façades and no balconies.
1963:	The American Institute of Architects holds a convention in Miami Beach at the Bal Harbour Sheraton. Lapidus attends, defending his design by asking, "Gentlemen, are you enjoying yourselves?"
1964:	Lapidus continues to design a number of large apartment houses along Collins Avenue.
1967:	Lapidus designs the Loew's of Monte Carlo for the Loew's Theatre Company. (He is not credited for it, though, since the German financier demanded a German architect.)
1970:	The New York Architectural League mounts an exhibit of Lapidus's work entitled "An Architecture of Joy," and Lapidus publishes a book of the same name. While the critics are still unrelenting, his work has developed a cult following—especially among postmodernist architects.
1971-1980:	Lapidus begins to design twenty-nine buildings for the tract of land in the northwest corner of Miami that will become the city of Adventura.
1981:	Lapidus designs the Daniel Tower Hotel in Israel, his most opulent resort hotel and also his last.
1984:	Lapidus decides to close his office of forty-one years, throwing all remaining drawings and models not retrieved by his son Alan into the incinerator.
1985:	Lapidus writes *Man's Three Million Year Odyssey*, which encompasses geology, anthropology, mythology, and history.
1989:	Lapidus collaborates with Martina Duttman on her book *Morris Lapidus: Architect of the American Dream*.

1991: The Netherlands Architectural Society mounts an exhibit of Lapidus's work, which he travels to Rotterdam to attend.
The Whitney Guide to 20th Century American Architecture includes the Fontainebleau as one of its definitive buildings.

1992-1993: Lapidus's wife dies at home.
Columbia University holds an exhibit of Lapidus's work. The architect enters Avery Hall, home of the School of Architecture, for the first time in seventy years.

1995: Lapidus speaks at the National Park Service's convention "Preserving the Recent Past."
Seventy-three years after he enrolled at New York University, the school presents Lapidus with a Lifetime Achievement Award.

1996: Lapidus publishes *Too Much Is Never Enough.*

1997: Lapidus lectures all over the country.
With the firm VVA Inc., Lapidus designs four stores for the company Roots of Canada and attends the opening of the Toronto Promenade Mall store.

1999: With VVA Inc., Lapidus designs Aura Restaurant, which is the subject of an article by Joseph Giovanni, and designs products for Acme Studio.
Morris writes his last two books: *The Fontainebleau and Eden Roc Saga* and *After My Heart*, the story of his relationship with his wife.
A plaque is put up on Lincoln Road honoring Lapidus.

2000: In November, the Cooper-Hewitt Museum names Lapidus An American Original, and on December 15, Lapidus gives his last public interview, to Charlie Rose.

2001: Morris Lapidus dies at home on the morning of January 18, at the age of 98.

Morris Lapidus at the construction site of the Americana, Bal Harbour, 1956.
Exterior of the Sans Souci, Miami Beach, 1947.

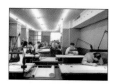

Interior of the New York office of Morris Lapidus Architects at 249 East
49th Street, New York, 1945.

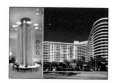

The Biltmore Terrace Hotel, Miami Beach, 1951.
The Seacoast East, 1961.

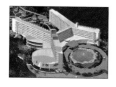

Model for the Trewlany Hotel, Trewlany, Jamaica, 1973.

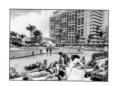

Pool and bar of the Americana, Bal Harbour, 1956.

Architectural rendering of the interiors of the Distillery Building for the 1939
World's Fair, New York, 1938.

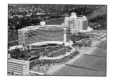

Aerial view of the Fontainebleau and the Eden Roc, Miami Beach, 1955.

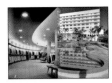

Interior of Bond Department Store, Chicago, 1945.
Pool and garden area of the Sans Souci, Miami Beach, 1947.

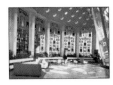

The atrium of the Americana, Bal Harbour, 1956.

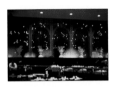

Interior of the Eden Roc, 1955.

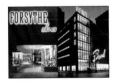

Forsythe Shoe Store, New York, 1929.
Bond Department Store, New York, 1936.

Morris Lapidus on Lincoln Road, Miami Beach, 1998.
The Aruba Caribbean Hotel, Aruba, 1956.

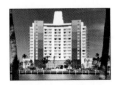

The Eden Roc, Miami Beach, 1955.

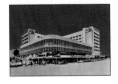

The diLido, Miami Beach, 1951.

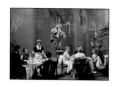

The Court of the Sun King restaurant at the Fontainebleau, Miami Beach, 1954.

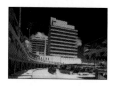

The cabana and pool area of the Eden Roc, Miami Beach, 1955.

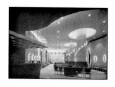

The Ansonia Shoe Store, 1943.

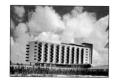

The Aruba Caribbean Hotel, Aruba, 1956.

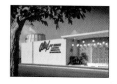

Alix of Miami, a women's clothing manufacturer, Miami, 1959.

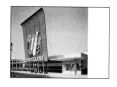

1939 World's Fair Distillery Building, New York, 1939.

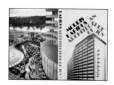

Exterior detail of the Eden Roc, Miami Beach, 1955.
Cover of Lapidus's book An Architecture of Joy.

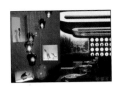

Stairwell of Morris Lapidus's apartment, 31 Terrace Towers, Miami Beach, 1997.
Cover of *Morris Lapidus: Architect of the American Dream*, showing the Seagrams sampling room in the Chrysler Building, New York, 1934.

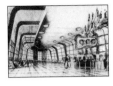

Rendering for the proposed lobby of the Liberty Vessel, a re-outfitting of a war vessel for use as a cruise ship, for Aetna Marine, 1943.

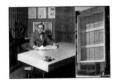

Bar at the Sans Souci, Miami Beach, 1947.

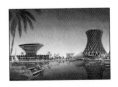

Morris Lapidus at his desk in his New York office, 1945.
Exterior of Morris Lapidus's New York office, 1945.

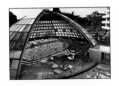

Rendering of the proposed International Trade Center in Miami, 1968.

Swimming pool of the International Inn, Washington, D.C., 1967.

Junior League Headquarters, Coral Gables, Florida, 1973.

To Morris, who shared his sunset years with me, while I in the middle of mine, learned volumes. To Mrs. Perricone, for the idea to write this book. Many thanks to the soul of Assouline—Karen Lehrman, Sarah Stein, and Ausbert de Arce. Thanks to all those who allowed me more absences than presences—Jason Bell, Quinn Ferrall, and Zachary Ferrall. And special thanks to Young Lonchiek. Dedicated in loving memory to Glenn Desilets.